100
KEYS
TO
GREAT
CALLIGRAPHY

JUDY KASTIN

North Light, Cincinnati, Ohio

DEDICATION

Dedicated to the memory of my father,
Ralph Bandes, who always said, "Never
say, 'I can't,' always say, 'I'll try'," and to
Jeffrey, Matthew, and Mom – with love.

A QUARTO BOOK

Copyright © 1996
Quarto Inc.

First published in the U.S.A.
by North Light Books,
an imprint of
F & W Publications,
Inc. 1507 Dana Avenue
Cincinnati, Ohio
45207. (800) 289-0963.

ISBN 0-89134-752-6

This book was
designed and
produced by
Quarto Inc.
The Old Brewery
6 Blundell Street
London N7 9BH

Manufactured by
Birght Arts (Singapore) Pte Ltd
Printed in China by
Lee Fung-Asco Printers Ltd

Contents

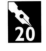

FOREWORD

WHETHER YOU ARE a hobbyist or a professional, whether you work in a luxurious studio or at a kitchen table, dipping into the information in this book will help make your letter making endeavors more satisfying and exhilarating. A compilation of tips and techniques gained from years of experience and experimentation, this book goes beyond the basics of lettering.

I am indebted, as we all are, to the teachers and students worldwide who have imparted their innovations and discoveries. This shared knowledge benefits the makers, and ultimately the viewers of calligraphy from informal correspondence to artistic pieces.

Concise shortcuts and advice are arranged by categories – everything from tools and materials to project ideas. There are tips that will introduce you to new materials, suggestions for modifying familiar tools, and a myriad of practical techniques to make projects colorful, enticing, and expressive. As invaluable as all these gems are, the only way to improve calligraphy is through lots of practice. A solid foundation in basic forms is essential. Watercolor backgrounds and decorative gold dots cannot hide poor writing. Practicing on cards and envelopes for friends and relatives has the added bonus of bringing great pleasure to the recipients. My own interest in lettering began with the envelopes my uncle sent me when I was a child. My name in elegantly flourished letters made a lasting impression on me.

Exploit happy accidents. One of the tips "Tricky Stripes," came about when my calligraphy marker accidentally touched the tip of a paint marker I had intended to use to highlight the lettering. Rather than wiping the paint off, I decided to see what would happen.

Always be open to serendipity.

Excellent books and periodicals offering instruction in historical and contemporary styles, as well as comprehensive anthologies of calligraphic pieces, are valuable resources. Emulate, don't copy, the work of accomplished calligraphers. Keep your eyes open – there is lettering everywhere. Start an archive of diverse and enticing samples. Take classes, and join a guild – there are over 100 groups around the world that provide study opportunities, lectures, conferences, exhibits, publications and networking. Collect texts that have meaning to you. Allow words to be your inspiration and strive to create works that enhance their significance.

Exercise moderation, good taste, and a critical eye – all of which can be developed through practice and observation. Resist using every technique you know in a single piece. As you continue to practice, experiment, and learn, you will find your own voice.

With its tremendous capabilities for altering and creating letterforms, scanning artwork, and adjusting and refining layout, the computer should be viewed as a friend not a foe. It has become yet another tool in an artist's palette, although it will never totally eclipse the unique joy and vitality of actually doing hand lettering.

Expand your repertoire – adapt the advice in this book for your own work. Apply calligraphy to other arts and crafts that you pursue. Whether you are a beginning or advanced student, this book offers valuable suggestions and ideas to try. Full of inspiration, information, and encouragement, presented in a compact and handy volume, this is one text you will want to refer to again and again. Calligraph your world!

JK

LETTERING TOOLS

CALLIGRAPHY MARKERS
Enjoy the hassle-free convenience of writing and flourishing with markers in a wide variety of colors, nib sizes, and styles (both broad-edged and brush). They are great for practice, layouts, and fun pieces, but are not recommended for works needing to last because they may fade. Look for firm, sharp nibs. Some even have "scroll" or split tips that make multiple lines. You can create your own scroll marker, by cutting a "V"-notch with a knife.

USING MARKERS Use light pressure to avoid breaking and softening the nibs. Try waterproof markers for smear-proof envelopes. Obtain a dry-brush effect with markers that are almost dried out. Use broad-edged opaque paint markers to write on plexiglass, wood, paper etc. Select textile markers for writing on fabric, and use a disappearing marker for guidelines. Experiment with these on paper, too.

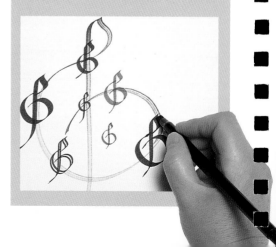

 DIP PENS
Fountain pens and markers are very convenient, but for *quality* work you must use dip pens (broad-edged and pointed metal nibs set in holders). These nibs allow you to produce sharp, crisp edges and hairline strokes, apply varying degrees of pressure, use mixed paints and ink, and write on all kinds of papers. Brands range in flexibility, design, and performance. Use one set of nibs for black, another for color.

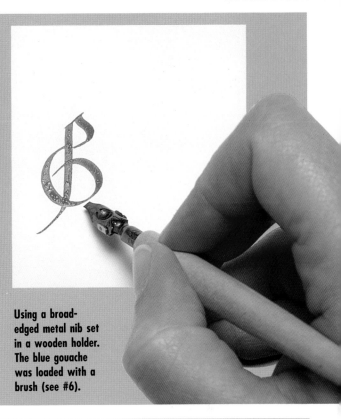

Using a broad-edged metal nib set in a wooden holder. The blue gouache was loaded with a brush (see #6).

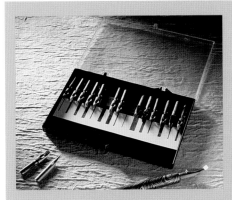

 PEN NIB CASE To make a handy nib holder, cut a piece of adhesive-backed magnetic tape to fit inside a small box. Lay your nibs on the strip in size order and you will readily be able to select the size you need. Label with a sample stroke of each nib size for easy reference.

HOMEMADE RESERVOIR

In order to hold more ink, some pen nibs come with a "reservoir." You can make one out of tape. Cut a strip of tape ⅛" × ⅞" (3 × 21mm). Place it across the underside of the nib at its widest point. Fold over the two ends of the tape to form an "X" on the top side of the nib. Discard the tape when you clean the nib. Try this on pointed copperplate nibs, too.

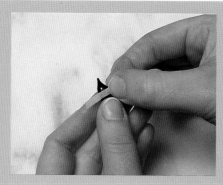

Place tape across widest part of nib's underside.

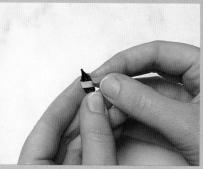

Fold ends over to form an "X."

LOAD WITH A BRUSH

Dip pens are not always dipped. The best way to control the amount of fluid (especially stick ink or paint) is to load the nib with a brush. Fill a small or medium round brush with ink or paint. Holding the brush in your other hand, touch the reservoir across the bristles to feed into the cavity. (A dropper could also be used, but the action of the brush helps keep the nib surface cleaner.) Be careful not to overload!

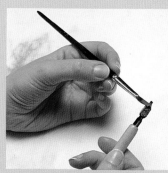

Loading the nib with a brush is more efficient than dipping it directly into ink or paint.

7

RESHAPING A BRUSH If the bristles on your brushes are damaged, splayed, or bent, clean the brush and then dip it into gum arabic. Reshape the tip by stroking it in the crook of your hand between your thumb and first finger. It will harden when it dries, and should be retrained. Rinse gently in water before reusing.

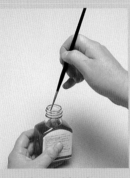

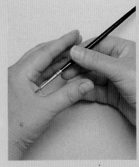

Dip a damaged brush into gum arabic.

Stroke the tip in the crook of your hand to reshape.

8

PENCILS Select hard (ranging from 2H to 7H) pencils for ruling accurate lines; soft (ranging from 2B to 7B) for doing sketches and layouts. Sharpen with standard or electric sharpeners; or use a knife to expose more lead for longer lasting points and for broader lines. Use a sandpaper block (or emery board) to maintain points. To create chisel-edged tools for layouts, rub soft pencils back and forth on one side, then turn over and repeat. Keep pressure to a minimum to facilitate erasing.

11

CARPENTER'S PENCILS To create a chisel-edged tool from a 2B to 6B carpenter's pencil, shave the flat sides with a razor blade or utility knife. Repeat on the short sides. Expose approximately $\frac{1}{3}$" (8 mm) of lead. Sharpen from side to side on a sandpaper block, holding at a 45° angle. Repeat on the other flat side. As you write, flip the pencil over often to retain the edge. Reshape as needed.

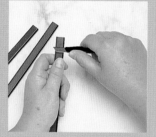

Shave the wood from the two flat wide sides.

SPONGE BRUSHES Inexpensive sponge brushes come in assorted sizes. They have a chiseled edge and are fun to use for large writing. Put any inks or poster paint (diluted, if necessary) into wide-mouth cups for easy dipping. Try "double dipping" (see #56). Use them for doing wide strokes for washes. Clean with soap and water.

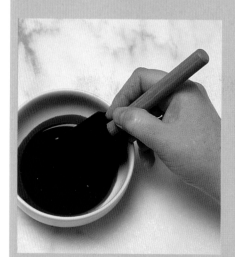

A wide-mouth container makes dipping a sponge brush easy.

Use sponge brushes for extra large lettering on posters, etc.

Repeat on the short sides.

Use a sandpaper block to bevel the two wide sides.

Try this broad-edged pencil for layouts.

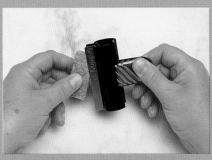

Cut a piece of felt and insert it into a "bulldog" clip.

FELT POSTER PEN Pull apart the felt layers of an ordinary chalkboard eraser. Use a utility knife to cut a piece to the width you desire. Insert into a standard "bulldog" clip. Dip into ink or paint. Hold at the angle required for your lettering style. Make large letters for posters, signs, etc. Remove felt from the clip to clean in water. Let dry before reinserting.

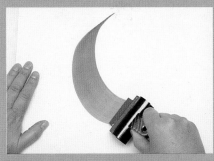

Dip into ink or paint and proceed.

The finished letter. Try double or triple loading for a multicolor effect (See #56).

UNUSUAL TOOLS A *twig* is a *twig* is a *pen*! Turn everyday objects into incredible writing instruments – then, discover and exploit their unique characteristics. For example: a strip of matboard will run out of ink, creating a "dry-brush" effect. Be creative with: sticks, pieces of wood, cotton swabs, a cigar, celery, wooden coffee stirrers (fine), popsicle sticks (medium), tongue depressors (broad), wood veneer, balsam wood, stimudent dental picks (split), several bamboo skewers (split), aluminum from soda cans, plastic from containers, pieces of leather or suede, basket reeds, clarinet or saxophone reeds, weatherstripping felt, brass flashing, . . . and who knows what else!

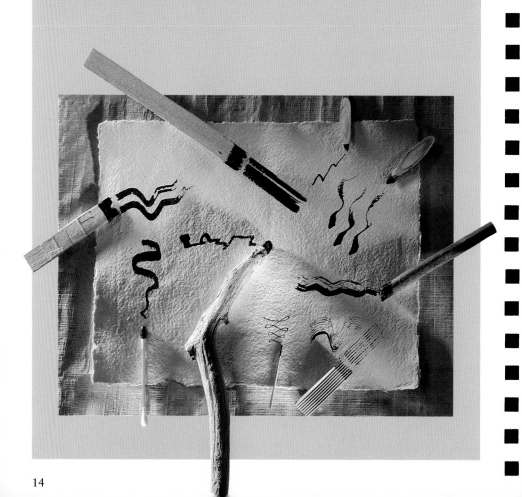

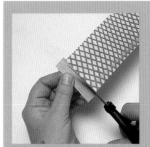

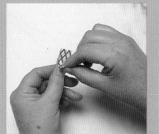

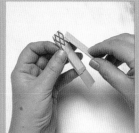

Cut a strip of tightly woven kitchen cloth.

Attach cloth to a balsam wood strip with tape.

Sandwich cloth between another wood strip.

 13 **HOMEMADE PENS** You can write with some of the unusual tools just as they are – others must be fashioned into pens. To trim, cut with sharp scissors or a knife. Sand the tip to make a chiseled edge if you like and to remove any roughness. If you can't hold it comfortably, cut the pen down to about 1" (2.5 cm) in length and try fitting it into a pencil-type adjustable grip X-acto knife holder; or tape (or screw) it to a pencil, chopstick, clothespin, etc. Custom cut the nibs to various widths. Make split "ribbon" pens by cutting a "V"-notch or using pinking shears. Discard or retrim when the nibs lose their shape.

Written with a home-made split pen.

 14 **NO-ROLL TOOLS** Cut and slit a piece of foam from a nail polish toe separator, or cut a ¼" (5 mm) slice from a children's triangular pencil grip, available in stationery stores. Push either of these onto the end of round handled tools such as X-acto knives, pen holders, pencils, etc. to prevent them from rolling off your table.

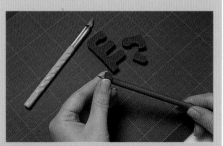

A piece of foam placed on the end of your tools will help keep them in place.

MATERIALS AND EQUIPMENT

15

SLANT BOARD Many calligraphers write at a slanted drawing table or board which can be adjusted for writing different styles. Working at an angle allows for an undistorted view of your work and also facilitates ink flow. To substitute for a store bought model you can use a wooden board 18" × 24" (45 × 60 cm) or larger, supported at approximately 45° to the table. You can butt it up to a yardstick or thin strip of wood (secured to the table edge with tape or clamps) or rest it in your lap, leaning against the table edge. [Note: *Flatten* the board for drawing or writing in watercolor or gouache in order to prevent puddling.]

DILUTED INK Replace bottled ink when it is no longer fresh (moldy or smells bad). However, if it is still good but just thick when you get to the bottom, add distilled water to thin it. Use for practice to help you see the skeletal structure of the strokes.

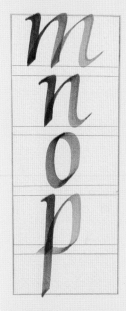

Diluted ink on newsprint shows where strokes branch and overlap.

INK BOTTLE HOLDERS Outline the shape of your ink bottle on an ordinary kitchen sponge. Cut *inside* your lines with a utility knife. The bottle will fit snugly in the opening, and drips will not be a problem! Or, cut an "X"-shaped slit (2¾" (7 cm)) in the center of a 4½" (12 cm) plastic container lid. Secure the bottle by pressing the slits down over it. Fit this into a second inverted lid.

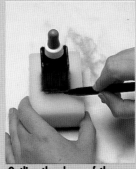

Outline the shape of the bottle.

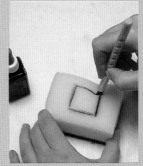

Cut and remove.

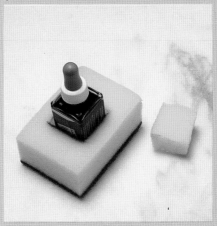

This handy holder keeps the ink bottle safe.

PREPARING STICK INK Place 4 or 5 drops of distilled water on the flat surface of an ink stone. Holding the stick vertically move in a circular motion in the water. Grind until a thick paste forms, but don't press too hard. Repeat the procedure 2 to 3 more times. Then push the thick ink into the well. Gradually add drops of water until you achieve the desired ink consistency. Use a brush to load your pen (see #6). Stick ink does *not* reconstitute well, so discard when finished. Wipe the stick and wash the stone.

18

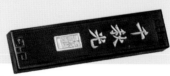

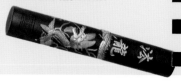

TACKY IDEA Removable plastic adhesive used for mounting posters has many calligraphic applications and is totally reusable. You can use it to secure your ink bottle, keep your tools in place, tack down your paper, and hang work up on the wall. Just pull off a piece and knead it. To remove every last bit, dab with a wad of the adhesive. Different brands come in various colors. [Note: Test to see if the color stains your paper or surface.]

19

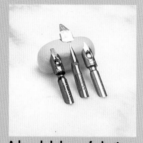

A kneaded clump of plastic adhesive keeps tools in place.

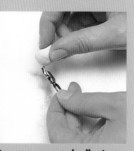

Remove unwanted adhesive by dabbing with a wad of the adhesive.

SELECTING COLORS Color choices depend on the intended purpose of the project, the paper, and the tools to be used. Colored markers, inks, concentrated dyes, watercolors, and gouache each give different results. Opaque designer's (*not* student grade) gouache in tubes (see #22) is usually the preferred choice for writing finished pieces. Colors have different degrees of permanence that should be considered for longevity.

20

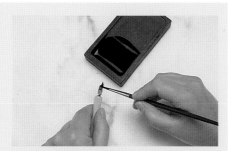

To use stick ink, load your pen with a brush.

The bottom half of this word had been covered with black paper. The unprotected colors in the top portion have faded.

PERMANENCY TEST

21

To see if your inks, paints, markers, or paper will fade when exposed to light, make a sample of each element you are testing on a piece of paper. Be sure to label the brand, color name, etc. for each test item. Cover half the test area with a piece of opaque black paper. Put it in a sunny window and check periodically for any color changes.

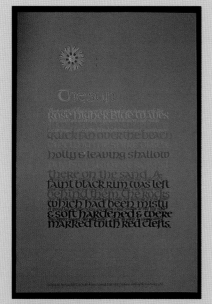

Mary White, _The Sun._
Uncial and italic letters written in gouache with metal nibs and touches of gold leaf convey the words in Virginia Woolf's poem about the sun on the waves.

USING GOUACHE Squeeze about ¼" to ½" (5–10 mm) of gouache ("gwash") into a small deep container. Add a little distilled water with a dropper. Use a small brush to mix to the consistency of light cream and to load the nib. It should flow easily yet still be opaque. To aid the flow, loosen the reservoir with a tweezer or needle-nosed pliers, and push it back slightly (some calligraphers remove it). To help gouache adhere to paper, try adding a drop or two of gum arabic. Clean your nibs often! Work flat, or at a shallow angle. As the paint evaporates, add water. Judge the color only when *dry* on a scrap of your final paper. Most colors can be stored and reused. If your tube dries out, split it open and reconstitute the color with water. Storage in plastic bags with a damp sponge helps keep paint moist.

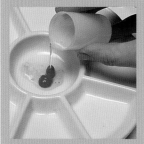

Add a few drops of water to the gouache.

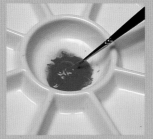

Use an inexpensive brush for mixing.

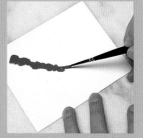

Testing the color on a paper scrap.

ORDER OF MIXING
Remember that it is easier to darken a light color than to lighten a dark color. (Adding a weaker color to a stronger one uses much more to obtain the same result.) When mixing a pastel color, for example, start with white and add the color drop by drop.

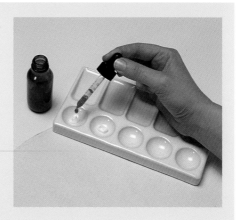

Save paint or ink by adding dark to light color.

MORE THAN YOU NEED When working with color always prepare more than enough to avoid running out, especially when you have mixed a specific color. Let leftover color dry for reconstitution later, or save it wet in a well-sealed glass bottle or plastic bottle or film canister. Attach a sample swatch. Record your "recipe" (see #87).

AVOIDING IMPURITIES Tap water may contain impurities and bacteria. Consider using distilled water for preparing stick ink or gouache and for preventing spoilage of paint mixtures you plan to reuse. When writing, keep a dropper bottle handy for adding to gouache as it dries out. If your paint mixtures develop mold, try adding a drop of denatured alcohol (methylated spirits) or peroxide, putting a piece of damp sponge inside the cover, and storing in the refrigerator.

26

OPEN SESAME! If your bottle or paint caps are hard to unscrew, hold under hot running water, grasp with a rubber kitchen jar opener mat, or wrap with a rubberband, then turn; or, use a pair of pliers or nutcrackers. Thoroughly cleaning and wiping the threads and inside of the caps after each use, applying a little petroleum jelly on the threads, or spraying lightly with nonstick aerosol vegetable spray will help prevent the problem.

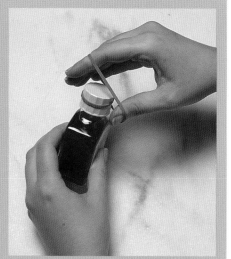

Wrap a rubber band around a stuck cap.

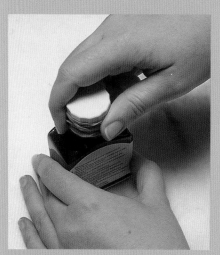

Twist to open.

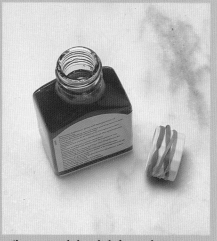

Clean cap and threads before reclosing.

HEALTH HAZARDS Manufac-turers are required to list health and safety hazards on all art materials. Read labels and be knowledgeable of any potential dangers. *Cadmium* colors for example, are extremely toxic, therefore you should never lick your brushes. Lead shavings from pencils are poisonous, so dispose of them properly. Be sure to wash your hands before eating.

GOOD RULERS A metal ruler with a cork backing is ideal for ruling neat lines. The cork raises the ruler preventing slippage, and ink or paint from seeping underneath. You could tape three (or more) pennies, or several strips of masking tape, to the underside of a ruler to achieve the same effect.

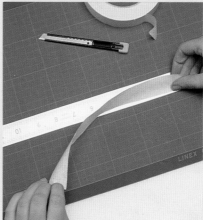

Apply a few layers of tape to the underside of a ruler.

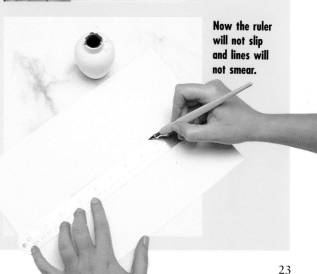

Now the ruler will not slip and lines will not smear.

23

LIGHT BOXES Light boxes can be purchased at art or engineering stores, or you can easily make your own.

• Set up a piece of plexiglass (see #15), with a fluorescent light (portable with batteries, or a plug-in stick fixture) beneath it.

• For small work, invert a slanted plexiglass cookbook holder or picture frame and use as above.

• Put a light source underneath a glass table for working flat.

• To trace or check layouts, tape your work to a sunny window!

[Notes: If your surface is not frosted, cover it with tracing paper or apply a thin coat of white paint to protect your eyes. Also be mindful of the heat from your light.]

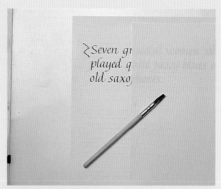

A purchased light box.

A homemade light box.

COPY MACHINE Having your own or easy access to a copy machine is a definite asset to a calligrapher! A machine that also reduces and enlarges in one percent increments is most useful. It can save time at the layout stage, produce some exciting effects, and inexpensively print some of your projects. Color copy machines offer even more possibilities.

GETTING STARTED

PRACTICING LARGER

31

When practicing a new alphabet, use a large pen nib, ⅛" (3 mm) or wider and black or diluted ink (see #16). This will allow you to see and recognize mistakes more easily. Resist the temptation to work smaller until you have gained some familiarity and proficiency.

Maria Vadenaker, *Oorstorong and Contrast*. To produce fine quality work like this, you must develop good practice skills.

IJLSCHAUKRDZPEMGFBNT
VXAYBWCIEDSO *A* FGJK
HLNQPMVOBXS *A* RTUI
JYZ *B* DACEHQGIKFLIP
MO *B* NRS *C* NTUWZX
VDBCAEIFP *C* GHMJKLR
SNOTNPQUXACWZUOGJ
BDHYEIKVOFLNPSQRUM
W *X* AYDGBXGJZ *Y* IC
EI *X* FHKMLOPTS *Y* SR
XUABYVDZGECWFJHKIM
NLRSP *Z* OSUZQSWDVCI
GDCF *Z* ABEWHKNSHKS
VIUNLMGLUQICBTVRTJH

ADPOUCDBQUEJ GFKLI
WHNRMSUTVX ZYCJ

TRACING IS OKAY

32

Tracing can serve as a temporary practice technique. Select the same nib size used for your alphabet model. Trace over the strokes following the proper "ductus" (stroke sequence), using a *dry* pen direct on the model, or ink or a marker on thin paper placed on top of your model (or on a photocopy of it).

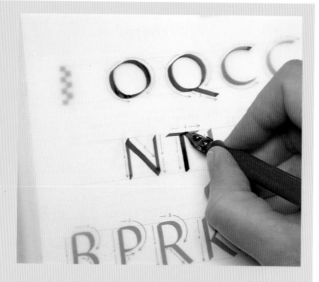

Using pen and ink on tracing paper over a model alphabet.

ALPHABET NECKLACE When you are learning a new alphabet, do not practice individual letters in isolation. Instead, string the letters together by inserting an "n" between each. Joining the letters this way will help develop rhythm and a sense of letterspacing, both of which are critical to good lettering.

33

anbncndnenfngnhninjnknlnmnnnonpnqnrnsntnu

ABECEDARIANS To practice different letter combinations, write "abecedarians" (sentences

34

that contain one or more of every letter in the alphabet), such as, "The quick brown fox jumps over the lazy dog." Check the letterforms as well as letter and word spacing. Rewrite to improve and check again. Make up some of your own.

Seven graceful women skaters played quite jazzy blues on old saxophones.

Write out abecedarians to practice your letters and spacing.

EASING TENSION If you find yourself grasping the pen too tightly, try this trick. Put a pencil in your other hand. Place the eraser on your paper

35

and squeeze the pencil continuously. By transferring the pressure away from your writing hand, you will lighten the tension in your grip allowing your lettering to flow smoothly and effortlessly – and your fingers won't cramp. Shake your hands periodically and take frequent breaks to avoid tendonitis, tennis elbow, and carpal tunnel syndrome.

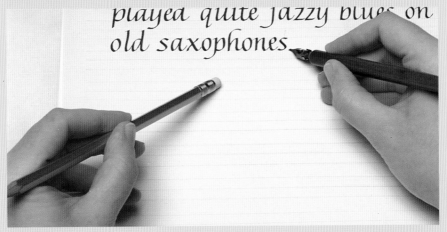

PRACTICING SMALLER Greater skill, precision, and control are needed for writing with small nibs. When practicing, a direct jump from larger to smaller nibs may cause your lettering to degenerate. Instead, follow a sequential system, progressing gradually down the scale in nib sizes. Keep to one size until you can achieve sharp strokes, accurate letterforms, and good spacing – *then* proceed to using the next smaller nib.

WORKING EXTRA LARGE To do extra-large lettering with pens or brushes, your writing arm must be able to move freely. Use your *whole* arm, not just your fingers. Try standing up for full freedom of movement across your paper. When practicing, use thinned poster paint or diluted ink. For instant guidelines, write on the classified pages of your newspaper turned sideways!

The classified section of the newspaper provides guidelines for large lettering. Be sure to find a nib size to suit the lettering style you wish to practice.

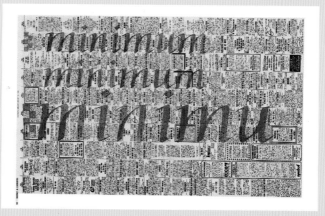

NO MORE WIGGLES To avoid shakiness in the long strokes of tall ascenders and descenders, or when you are doing large lettering, try inhaling before putting your pen to the paper. Then exhale and relax on the downstrokes. Your wiggles will disappear! Practice until this feels comfortable and natural.

39 WRITE THIS WAY Try some of these methods to get the feel of an alphabet style or to loosen up: Write with your eyes closed or with your other hand. Pick your hand up and write in the air. Don't use any guidelines. Change to a different kind of tool (a regular pointed marker or ballpoint pen), or a much larger size tool. Change to a smoother or rougher paper. Listen to music as you work and follow the rhythm.

40 WATCH THE TOPS Did you know that we read words by looking at the *tops* of the letters? The distinguishing features that we perceive are embodied in the upper half of the letterforms. Be mindful of this when you evaluate your calligraphy! Check for problems with branching, joins, flourishes, and spacing, as well as the unique aspects of each alphabet style.

Nancy Leavitt,
The Seafarer.
Cover the top half of the calligraphed title with paper. Can you read it? Repeat covering the bottom portion.

COLOPHON

The manuscript pages were lettered by Nancy Leavitt. She chose key phrases from the original Anglo-Saxon to illuminate the translation. All the pages were printed on a cylinder proof press using hand set Méridien types & photo-engraved plates. The handmade papers are Kumoi, Uwa, Saint Gilles & Twinrocker. The bindings for copies two through forty-six were designed & assembled with Daniel E. Kelm at his Wide Awake Garage, Easthampton, Massachusetts. This collaboration was created by Tatlin Books in an edition of eighty-five copies in Bangor, Maine. 1990.

LAYOUT AND DESIGN

THUMBNAIL SKETCHES

Do quick, small, scribbled renderings using a pencil or pointed marker. By manipulating the elements on these proportional experiments, you will resolve your layout questions. Writing out the entire text at full size in ink would only waste time and energy. Do several versions to explore all the possibilities. One design idea leads to another.

ROUGH SKETCH

Once you have chosen the thumbnail sketch that best satisfies your intentions, prepare a "rough" (full size working plan). First using pencils, then markers or pens, work out lettering styles, pen sizes, spacing, placement, margins, color, etc. Work on tracing paper or thin layout bond to see through and make progressive adjustments and improvements.

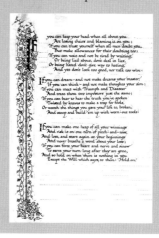

43

SIZING UP OR DOWN It's easy to reduce or enlarge the size of your layout and keep it in perfect proportion. Simply extend the vertical and horizontal edges. Draw a diagonal line from the lower corner through and beyond the opposite corner. Choose any height or width for your new dimension. Draw a line from that point to the diagonal line, and then, from the diagonal line to the other side.

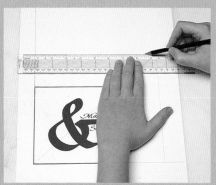

Use this simple method to determine a new size for your work.

44

PROPORTION WHEEL This handy scale is particularly helpful when you are doing work for reproduction and you need to know an exact percentage for enlargement or reduction. Line up the original size with the size you ultimately want – on the inner and outer wheels. The percentage of reduction or enlargement will appear in the window. (Full instructions are on the wheel.)

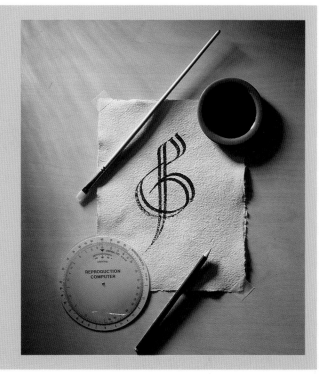

45 **DETERMINING MARGINS** Be aware of the proportion of text to white area. Note the positive and negative shapes you create when writing. White space should be part of your initial design, as it affects the general mood of a piece. More breathing space is usually desirable. It is safer to leave too much rather than too little extra blank area around your work before final cropping or matting.

46 **L-SHAPED CORNERS** To determine the ideal size and placement of your composition, experiment with two L-shaped pieces of black matboard or paper (white for dark papers). Move these corners around to obtain the desired visual effect of traditional aesthetics or unconventional imbalance. This technique also works in the layout stage or to find the most suitable section of a larger background sheet.

Henny van Renselaar
Fantasy text written in ink.
Extra wide margins set off the long text column. White gouache creates interesting shapes in and around the letters (see #68).

Match up the first and last letters of a line; crease at the middle.

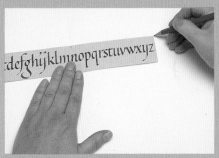

Mark the beginning, middle, and end.

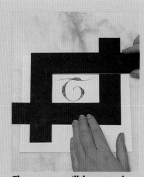

The corners will be moved out to find the perfect fit.

FINDING THE CENTER

1) Use a centering ruler.
2) Match the right ends of a line (or space) and a longer strip of paper. Mark where the line begins on the strip. Fold the strip's right end to the mark and crease. Mark the line's center.
3) Write on layout or tracing paper (or use a light box). Fold your paper to match the beginning and end of a line. Crease and mark the center.
4. Cut out a line of writing, fold it in half. Mark as shown.

EQUAL DIVISIONS

48 Here's a quick way to divide any space into *any* number of equal sections. For example, to divide a rectangle into five equal horizontal parts, hold a ruler (any calibrations) with "0" at the bottom left hand corner. Angle it across to the top side until it meets any measure that is divisible by five. Mark the divisions. Use a T-square or triangle to draw your lines.

Mark the calibrations that are divisible by five.

Use a triangle to draw lines.

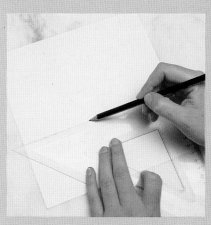

You will have five equal sections.

AROUND A CIRCLE To figure out how to fit a text around a circle, first write it out in a straight line. Divide that line into four (or eight) equal parts. Divide your circle into quarters (or eighths). You can now relate which words belong in each section. Apply this method to writing on an arc, around a border.

49

FLOURISHING Flourishes are like the icing on the cake. Well-executed flourishes add beauty, grace, and interest to your calligraphy. However, you must avoid overdoing and overusing them. When in doubt – leave them out! Perhaps an elegant or fun flourish at just the top and bottom of the page are sufficient. Remember to leave enough space for your flourishes. Hint: Keep the decorative elements lightweight to aid legibility.

51

FLOURISHED CAPS Beautiful flourished capitals are most effective when used sparingly, such as at the beginning of a word, or paragraph, though it can be tempting to write out whole words or lines in

50

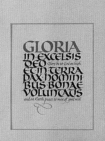

Jeanyee Wong, *Gloria in Excelsis Deo.*
Simple caps and flourish add strength and grace.

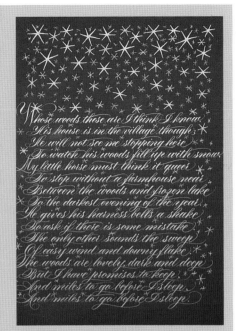

Mike Kecseg, *Stopping by Woods on a Snowy Evening.*
Lightweight flourishes skillfully executed.

SEEING YOUR WORK "The question is not what you look at, but what you see." – Thoreau. Spend time looking at your work. Your perspective will be better when you hang work on the wall and stand back. Look at your work upside down or in a mirror. Squint. See the overall pattern and design rather than individual letters. Look again tomorrow with fresh eyes.

AVOIDING RIVERS As you work out your layout with the actual tools you will be using, examine the overall piece to check for accidental holes or "rivers" (channels of white space), running through the text. If there are any, the eye will automatically be drawn to them (see #52). Slight adjustments to your letter and word spacing, and possibly to the ascenders and descenders, can solve this problem.

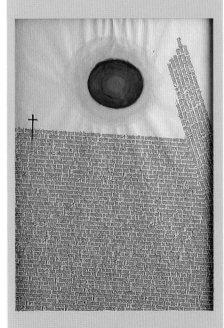

Ward Dunham, *Merton/Borelli.*
The letters and words have been arranged to avoid unwanted rivers and holes.

NEED ENVELOPES?

Planning to make or print something that will need envelopes? Think ahead to save time and money. Design the finished pieces to fit into *standard* size and color envelopes that your supplier or printer has in stock. Check postage costs related to the weight and size of the stuffed envelope. Select envelopes that will be *easy* to write on.

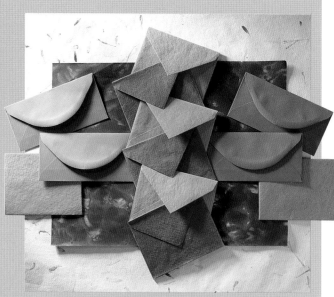

GANGING UP Before you plan to have something printed (or photocopied), consult with your printer to see what size paper will be used. If your job will have to be cut down from a larger sheet, you might be able to utilize the "waste" paper to print something additional. You can save money by "ganging" (pasting-up together) two or more projects that use the same ink. They will be printed as one job, and then cut apart.

SPECIAL EFFECTS

A brush is used to load a felt pen (see #11) with three colors.

 56

DOUBLE DIPPING Load the right side of a wide nib (or brush) ¼" (5 mm) or larger using a small brush dipped into one color of ink or paint. Use a second small brush to load the left side with a second color. As you write, you will see a striped effect, with the colors blending. For extra wide pens, try loading a *third* color in the middle, as shown.

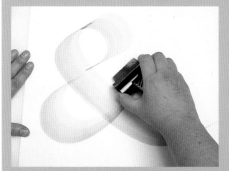

See how the colors blend into each other as the letter is formed.

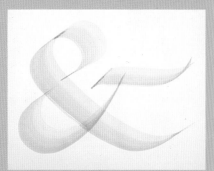

The result resembles a multicolored striped ribbon.

CHANGING COLORS To write with transparent or opaque colors in graduated, subtle tones (i.e. dark to light), or bright rainbow combinations, use a brush to load a little of one color into your pen, then write. Clean the brush (or use another one) and reload with a second color. The colors will blend and change as you write. Repeat with subsequent colors. For continuity, change colors in the middle of letters rather than words. [Hint: Plan for stronger colors where emphasis and/or legibility are needed.]

Julia Vance, Book jacket.
Gouache was blended in an automatic pen.

DROPPED IN COLOR Dip a wide pen or brush into water with a little ink or paint added to it and write. Work on a flat surface. Then dip a small brush, nib, or dropper into ink, watercolor, or gouache, and lightly touch it to several spots on the wet strokes. Repeat with additional colors. Tilt the paper so that the colors will spread and blend as they run into (but not beyond) the edges of the wet strokes! [Note: if the wide-pen strokes dry too quickly, rewet them with a drop of water.]

By tilting the paper the colors spread into each other.

MASKING Want to keep color out of certain areas? Try masking fluid. Dip a pen (without a reservoir) or a brush into soapy water, then into masking fluid. Apply to paper (watercolor paper works well). When dry (rubbery), go over masked area with any color using any method (spatter, wash, etc.). When *thoroughly* dry, rub away with a rubber cement pick-up, a plastic eraser, or your finger, to reveal the original surface underneath. Try masking tape for a resist with sharp edges. Wash tools immediately!

Write with masking fluid. Allow to dry.

Spatter paint directly over the masked area.

When the paint is dry, gently rub the masking fluid away.

The original surface of the paper will be revealed.

FUN WITH MARKERS

60

Experiment with various combinations of non-waterproof, waterproof, paint and metallic markers in different sizes and nib styles.

• Use a second color marker (same or narrower size or monoline) to go over your original strokes (down the middle or on one or both sides).

• Rewrite only the upper or lower half of each letter with a different color marker in the same size.

• With the same size nib, change colors every stroke (or two), line, etc.

• Add decorative touches (see #67).

PAINT WITH MARKERS

61

Use a *wet* brush to spread and blend *non*-waterproof (water based/*non*-permanent) marker strokes.

• Write with a scroll (split) marker and use a brush to spread the color into the blank lines.

• Use two colors to construct the sides of a letter. Blend them together.

• Make the outline of a letter with a *waterproof* marker. Apply color to part of the inside. Use a brush to fill in the rest.

• Put a few strokes onto a palette, dish, etc. Dip brush and use as paint.

• Combine any of the above. Try them *over* other non-waterproof or waterproof markers for different watercolor effects.

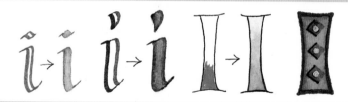

TRICKY STRIPES Touch *any* broad-edged marker to *any* paint marker, loading some paint color onto the center (or side) of the nib. Select colors that blend well. As you write the striped effect will gradually fade to the original color.

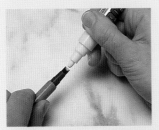

Loading a paint marker onto the tip of a calligraphy marker to make striped pen patterns.

Frequent loading retains consistent color. Only one loading gradually changes back to the original color. Wipe paint off nib when done.

COLORED PENCILS There's so much you can do with colored pencils!
• Create a chiseled edge for writing (see #8).
• Color inside, between, and/or around your letters.
• Fill in outlined letters with solid color or patterns.
• Color in some or all of the missed parts of dry-brush strokes, or the spaces between the strokes created by multiline nibs.

Will Farrington used colored pencils to go over the letter he had written in ink.

GLITTER WRITING Write with a chisel-edged glue stick. Sprinkle with colored or iridescent extra-fine glitter. Shake off and save the excess. Depending on how wet the glue is, work on only a small section at a time. You can use your fingernail to push the glitter around to perfect the shapes of the letters.

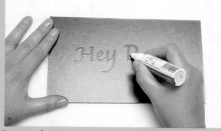

Do your lettering with a broad-edged glue stick.

THERMOGRAPH IT To give your calligraphy a raised look, write with a special broad-edged *thermography* marker, embossing ink, or a chisel-edged glue stick. For monoline or outlined lettering, use a regular erasable ballpoint pen. Sprinkle on clear or colored thermography powder (from rubber stamp suppliers). Shake off and save the excess, being careful not to inhale the fine dust. Apply heat from a heat gun, hair dryer, iron, or toaster oven until the powder bubbles and melts. Use for a whole word or just a decorative initial. This can be particularly effective on dark colored paper.

Embossing powder is sprinkled onto a letter written with a glue stick.

The excess powder is saved.

A heat gun is used to melt the powder for a permanent raised effect.

Sprinkle glitter while glue is still wet.

After shaking off the excess glitter, the letters sparkle!

COPIER TRICKS Add texture to lettering using black ink (or markers) and these techniques, then photocopy.
- Write on rough watercolor paper (cold press) or a paper towel; or, enlarge lettering significantly.
- Scribble white crayon on white paper, then write over it.
- Add white dots and/or lines or spatter with white paint.
- Crumple wax paper. Flatten on top of lettering.
- Lay white cheesecloth, lace, mesh, etc. over lettering.

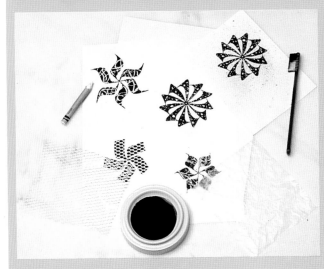

Pen-made flowers with texture from white crayon, spattered white paint, mesh, and crumpled wax paper.

DECORATIVE TOUCHES

67

From reserved to flamboyant, there are infinite ways to embellish a letter, word, or line – using a variety of tools and mediums.

• Outline the lettering with a thin black, colored, or gold line.
• Add shapes, such as dots, in gold or contrasting color(s).
• Create a shadow slightly to the left and bottom of each stroke (or a highlight to the top and right).

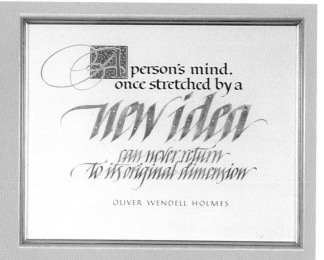

**Diane von Arx Anderson, *A Person's Mind.*
Decorative elements were artfully executed.**

FILLING IN COUNTERS

68

One basic way to decorate letters is to fill in the inner shapes. Leave a "moat" (a thin line all around, where the paper shows through), or fill the entire counter. Diverse materials and techniques can be used. Try one or more solid colors, cross-hatching, stippling, patterns (i.e. a checkerboard), etc. You may choose to fill all, specific, or random spaces both in and also around the letters.

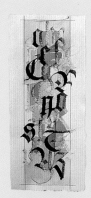

**Sherrie Lovler, *Alphabet*
Written with a popsicle stick. Gouache was used to add color.**

CLIP ART Even if you cannot draw, you *can* add illustrations, borders, and ornaments to your calligraphy by using copyright free designs. Clip art books categorized by topic are readily available. Select a design and photocopy it at your desired size. For reproduction, cut it out and position directly onto your paste-up. For a one of-a-kind piece, trace or transfer it onto your final paper.

COLORFUL COPIES Enhance your photo-copied or printed work:
• Add highlights, shadows, decorative dots, etc.
• Leave out a few capital letters or key words from your paste-up. Then hand letter them in color on each copy.
• Use paper with preprinted full-color designs, borders, etc.
• Add rubber stamps, stickers, photos, or other items.
(Alternately, make one full-color original, and reproduce it on a color-copy machine.)

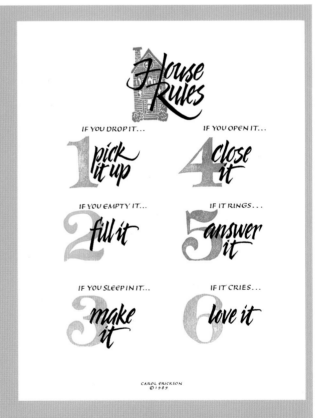

Carol Erickson, *House Rules*. Rubber stamps for the house and numbers add color and whimsy to the photocopied lettering.

BACKGROUNDS

71 **STRETCHING PAPER** To prevent your paper from buckling when working wet, immerse your paper totally flat, in a clean sink, tub, or tray of cold water (or wet both sides under running water) until fully saturated. Lift paper by one side, letting excess drain off opposite corner. Carefully lay wet paper, top side up, on a board larger than your paper. (Alternately, place paper on a board and sponge both sides.) Dab any remaining water and smooth the wrinkles with a sponge. Wet and apply strips of 2" (5 cm) brown gummed paper tape, overlapping edges of the paper by ½" (10 mm), long sides first. Let dry *naturally*. Leave fastened while using. When piece is completed, use a knife to remove it from the board.

Water is drained off one corner of the thoroughly wet paper.

The paper is placed on a board and the wrinkles are smoothed with a sponge.

Gummed paper tape is applied to all four sides. The paper is left to dry.

FLAT WASH Dilute a liberal amount of *one* color watercolor, gouache, or ink with water. With a large brush or sponge, dampen stretched or heavyweight paper (attached to a 10° to 15° slanted board). Dip a large ¾" to 1" (15–25 mm) flat or round brush into your color. Draw a smooth, light-pressured stroke *all* the way across the top. Reload. Allow each consecutive band to overlap, picking up the wet pool of color from the previous lower edge and redistributing it. Use a sponge, paper towel, or damp brush to soak up the excess water from the bottom edge of your paper.

A fully loaded large brush is drawn across the paper slightly overlapping the previous band of color.

The finished flat wash.

WASH DOS AND DON'TS For strokes to blend evenly and to avoid streaks, slant your board, and work *quickly* from top to bottom. Don't be stingy – premix a generous amount of color. Stopping midstream will spoil your wash. Load your brush fully (without dripping), so you won't run out mid-stroke. Reload after *every* stroke. Move your *whole* arm. If it helps, stand. [Hints: Don't rework your brushstrokes. Working on smaller paper is easier. A hair dryer can be used to speed the drying. Practice!]

FIVE WASHES There are several ways to create washes:

• **Variegated** (2 or more colors): Do some bands of a one-color flat wash. Rinse brush. Repeat with a second premixed color.

• **Graded** (dark to light): Start with full-strength color. Add more water with each successive band, ending with almost clear water.

• **Two color graded**: Apply a one-color graded wash, ending halfway down the paper. Turn the board upside down. Repeat with second color, meeting them in the middle.

• **Blending two colors**: With board flat, do flat wash of first color, partway. Turn board. Repeat with second color, overlapping the first. Tip board to blend colors together.

• **Variations**: Apply colors randomly or in waves. Add more layers of color. Use clear water to blend bands that do not overlap. Tilt the board in different directions.

Graded

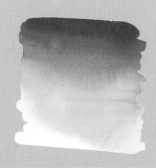

2-Color Graded

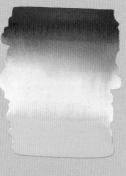

Random

Variegated Variation

Blending 2 Colors

WASH TREATMENTS After applying a wash:
• Spray denatured alcohol (methylated spirits) when still damp.
• Sprinkle coarse kosher salt, when wet but not dripping. Brush off when dry. Try other kinds of salt.
• Drip clear water or different colors when damp.
• Spatter by flicking a toothbrush or stiff brush, or by tapping a brush onto wet or dry paper.
• Dampen a natural sponge, dip in color, and dab onto wet or dry paper. (Try the last two methods on plain paper without a wash, as shown.)

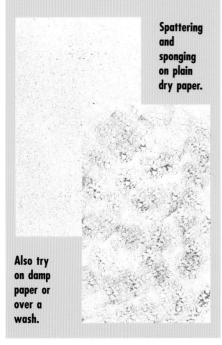

Spattering and sponging on plain dry paper.

Also try on damp paper or over a wash.

ADDING TEXTURE Place a piece of kitchen plastic wrap onto a very damp wash. Press it down and push to form wrinkles. Remove when totally dry (see this technique used in the illustration for #49.). Also experiment by pressing, touching-and-lifting, or twisting any of the following items onto a wet colored background: blotters, sponges, bubble wrap, cheese cloth, lace, crumpled paper toweling, tissues, waxed paper, or aluminum foil.

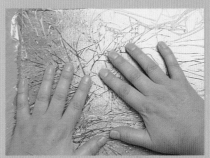

Wrinkles are being manipulated in the plastic wrap that was placed over a damp wash.

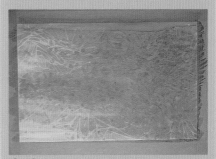

The plastic was removed when the paper was dry, resulting in an intriguing texture.

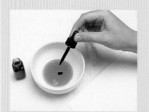

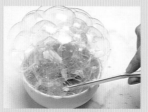

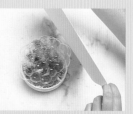

Color is added to liquid dish detergent.

A straw is used to blow bubbles.

A piece of paper is placed right on the bubbles.

77

BUBBLE PAPER In a wide-mouth container, mix ½" clear or white, or any liquid dish detergent (or children's bubble liquid), 1 teaspoon of colored ink (or a few drops of food coloring), and 1 to 2 tablespoons of water. Insert a straw and blow bubbles until they rise well over the top. Invert a sheet of paper onto them, then lift it off. The bubble pattern will transfer onto the paper! Repeat with the same (or other) colors. Cover all, or part of your paper. Experiment with different colors, proportions, container sizes, and papers for various designs and intensities.

The pattern of the bubbles has transferred onto the paper creating a delicate background.

78

STRAW BLOWING Deposit a puddle of ink or watercolor on your paper. Use a straw to blow it all around. When dry, (or while still wet, to blend), repeat using the same or different colors. Does the resulting design suggest a picture or a feeling? Think of some words or select a poem to strategically place on your unique composition.

79 **RULING LINES** Avoid erasing lines and smearing the writing on your final piece, by working on a light box (see #29). Rule your lines: 1) in pencil or marker on a separate piece of thin paper, and tape it to the back (underside) of your piece; or 2) in pencil on the *back* of your paper. For a different effect try ruling with a bone folder or other blunt edge.

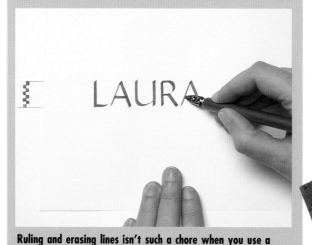

Ruling and erasing lines isn't such a chore when you use a light box.

80 **BUYING PAPER** Purchase paper larger than you need for your finished piece so that you can test your colors and nibs on an actual sample. You can make notes or test marks on the outer edges, and trim to size when completed. Always buy *extra* to have on hand in case you make a mistake.

THE "CURE-ALL" Gum sandarac is a natural resin that can be purchased, preground to a fine powder or in chunks (use a mortar and pestle to grind). Place 1 to 2 tablespoons in a silk or cotton square, or thin sock secured with a rubberband or string. It adds "tooth", allowing for sharp strokes and fine hairlines when writing on slick or porous paper, over backgrounds or corrections, and for writing small with stick ink. Dab gently on your paper or dust on with a cotton ball. Use sparingly. Remove excess with a soft dry brush. [Caution: Some people are allergic!]

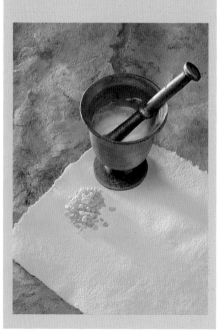

MADE A MISTAKE? Before making any corrections be sure your mistake is dry. Depending on your choice of color and paper your degree of success will vary. The more porous your materials the more difficult your task. Be sure to perform a test correction on a sample with the same materials. You can protect the surrounding area with an "eraser shield" or removable self-stick notes.

MAKING CORRECTIONS Gently scrape away your mistake with a curved #10 X-acto knife, scalpel, or razor blade. (Or, alternate between a typewriter or electric eraser and a white plastic eraser.) Then refinish the paper by laying a scrap of the same (or bond) paper over the area, and burnish (rub) the fibers down with a burnisher or your fingernail. Next, use a white plastic eraser to softly buff and remove any shine. Dust with gum sandarac (see #81). Use the same ink or paint sparingly to rewrite. [Hint: If your writing feathers when you rewrite on your test, first make your correction right on top of the mistake, then when dry, remove only the unwanted parts, as above.]

123456789

Oops! Everyone makes mistakes. Learn how to correct them.

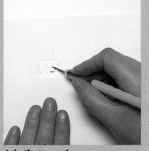

A knife is used to scrape away the mistake.

After burnishing, use a plastic eraser.

Dab with a gum sandarac pouch.

Make sure the nib is not too wet when rewriting.

BRUSH, DON'T BLOW

84

To remove erasure particles, excess gum sandarac powder, dust, etc., use any size soft, clean, dry brush, a drafting brush, or a feather. Never blow on your work because saliva could accidentally mar your efforts!

HELPFUL PROCEDURES

"TWINNING"

85 Reduce the fears of tackling your final piece by working on *two* copies at once. Execute each phase on both sheets, assembly-line fashion. If you make an unsalvageable error on one, just continue on the "twin." You won't have to start *all* over from scratch!

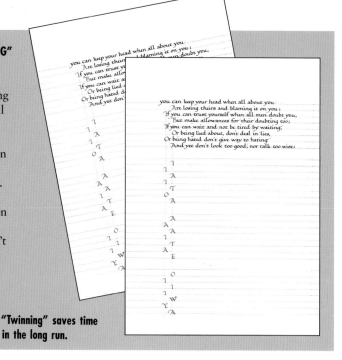

"Twinning" saves time in the long run.

SEPARATE ELEMENTS

86 Are you still too timid to combine artwork and calligraphy on the same piece because you are afraid of making an uncorrectable mistake on one of them? Do your writing on the paper, and your artwork, illustration, etc. on the mat – or vice-versa! Plan for the separate elements to work together or to complement each other.

Judy Kastin, *Les Fleurs*. The flowers were painted on rice paper with deckled edges (see #94.) The lettering was done on the mat.

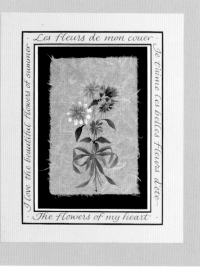

TECHNICAL JOURNAL

You won't have to reinvent the wheel if you keep a "technical journal" of your work. Record the brands, sizes, colors, plus any other pertinent information about the tools used. Note the recipes for exact proportions used to make mixed colors. Keep your notes, sample swatches, and final layout in a notebook, folder, or envelope. Next time you attempt a similar project, you will save time.

Keep a record of all materials and techniques used for each project. Jotting down the time spent is also helpful.

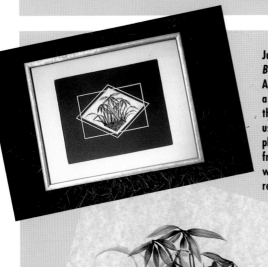

Judy Kastin, *Bamboo N.* A color trial, a piece of the papyrus used, and a photo of the framed piece will be retained.

RECORD OF YOUR WORK

When you have finished a special piece, a job, or a wonderful envelope, take a good photograph, or a black-and-white (or color) photocopy for your records. If you had made a mistake and started over, keep that attempt (finish it if you can) for your portfolio. You will have reference samples for future projects or to show clients.

89

CALLIGRAMS
Calligrams are compositions in which words or letters form the design. You can repeat a word or phrase or write an entire poem or text. Lightly outline the shape in pencil and letter around it, turning your paper to maintain a consistent pen angle; or draw a shape and fill it with lettering. Try changing pen sizes, styles, colors, etc. Erase all outlines.

Villu Toots created this charming rooster calligram.

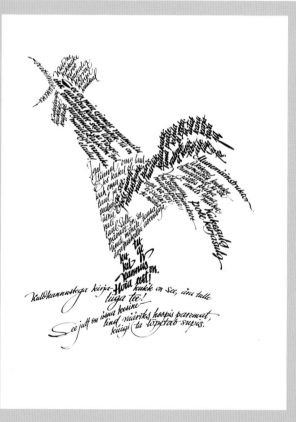

SCORE N' FOLD After measuring and marking where your fold will be, run a paper clip, bone folder, or any blunt instrument, alongside a ruler, to make a gentle impression in the paper. Lift and fold over on the line. Run your fingernail, bone folder, or back of a spoon on the crease. [Hint: To avoid making the paper shiny, place a piece of tracing paper over the crease, before using fingernail, etc.]

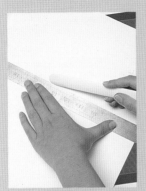 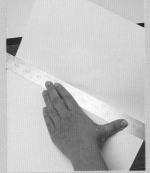

Using a bone folder to score the paper before folding.

Lifting and folding the paper.

Using the bone folder to make a sharp crease.

CUT IT RIGHT Place paper on a self-healing mat, or a piece of matboard. Using a metal ruler or straight-edge, cover the part of the paper to be saved (in case you slip). Grasp the knife lightly, holding it at an acute angle cutting with more than just the tip of the blade. Make numerous passes until you cut through. Replace dull blades often.

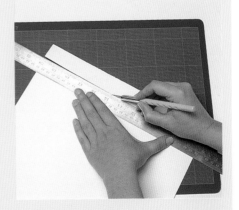

TIPS FOR PROJECTS

 NO-SEW BOOK Make this either totally hand written and decorated on rectangular or square paper, or have it printed (all on one side!), on standard size paper. 1) Fold in half widthwise, 2) widthwise again, and **92** 3) lengthwise. 4) Unfold two times and cut from folded edge to center. 5) Unfold. 6) Fold in half length-wise. 7) Hold end quarters and push together until they meet. 8) Close the book. 9) Crease with bone folder.

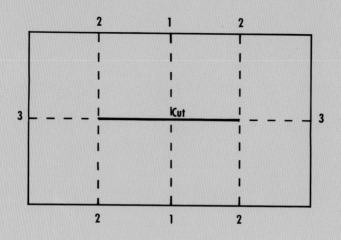

Fold and cut to make this clever book.

 EASY-SEW BOOK Cut paper for the pages to any size. Make the cover from heavier stock, slightly larger all around. Score and fold each piece in half and arrange them. Mark 3 (or 5) holes for sewing. With a darning **93** needle, *carefully* poke holes through *all* folds. Thread needle with heavy linen or embroidery thread (no knot) more than twice as long as the spine. Sew, tighten, tie a double knot, and trim. Do your writing, etc. before or after the book is assembled.

94

DECKLED EDGES Hold a ruler ¼" to ½" (5–10 mm) from the edge of your paper, (fold and unfold there for heavier stock). Dip a small round brush in clear (or colored) water, and run a thin line alongside the ruler to weaken the fibers. Pull apart slowly and gently, wiggling to make a new, uneven raw edge on one or more sides. An alternate method is to use fine sandpaper to roughen the cut edge(s) of your paper. Try these techniques to create other shapes.

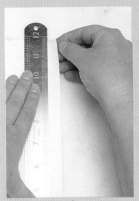

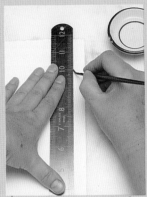

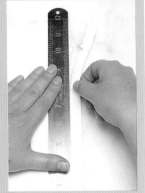

Fold heavyweight paper against a ruler.

Make a line with a wet brush.

Tear off to create an irregular deckled edge.

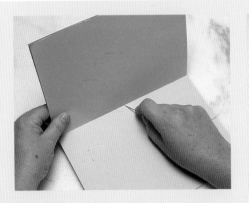

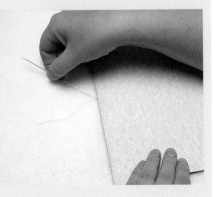

GOLDEN EDGES Add an elegant touch of gold by placing a strip of masking or removable tape about ⅛" (3 mm) from the edge of your paper. Then use a metallic gold marker or dip a sponge into any kind of metallic gold paint and dab along the edge. Remove the tape. Alternately, apply a glue stick or embossing ink, sprinkle gold embossing powder, remove tape, and use a heat gun (see #65).

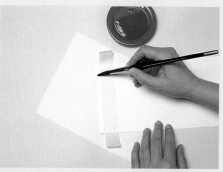

Tape is placed near the edge and embossing ink is applied.

ENVELOPE TEMPLATE Design your card to fit any envelope you already have. Simply unseam the envelope, lay it on heavy paper, such as a manila folder, trace around it, and cut it out. Use this pattern to mark the outline on your chosen paper. Cut, mark creases, score and fold (see #90), then glue where needed. Hint: For a see-through envelope use heavy vellum tracing paper.

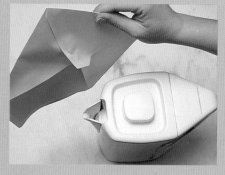

Steam open a ready-made envelope.

A reusable template is made from heavy stock.

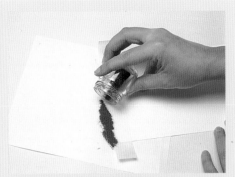

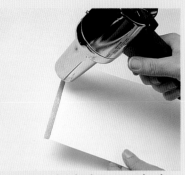

Embossing powder is sprinkled onto the wet ink. The excess is poured off and saved.

The tape is removed and a heat gun melts the powder for a luxurious gilded look.

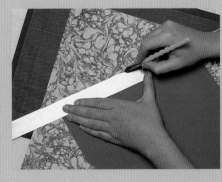

Select any paper to complement your card. Trace the pattern and cut it out.

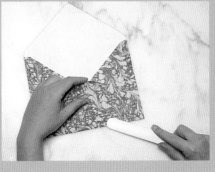

Use a bone folder to score and fold. Apply glue to complete your custom-made envelope.

MAKING ENVELOPES

97 Trim a paper to be larger than twice the width and length of your card. Place the card sideways in the center of the paper, then move it up, leaving more space below it. Fold two sides in, crease, and unfold. Repeat on other sides. Cut off the 4 corner shapes. Optional: Trim side edges of each flap on a diagonal. Fold sides, then the bottom. Insert card. Fold top down and glue, wax, or apply a sticker.

98 **DRYING RACK** Score and fold a 5½" × 11" (14 × 28 cm) piece of heavy card stock in half lengthwise. Draw a line ⅞" (15 mm) from the long open edge. At the fold, mark every ⅞" (15 mm) and 1" (2.5 cm) mark. Draw lines and cut out the ten slits. Spread the two long sides 4" (10 cm) apart. Optional: tape them to a 5" × 11" (12 × 28 cm) piece of matboard (which has been scored and folded in half lengthwise and placed fold down). Insert your envelopes or cards, etc. to dry. Make several. Fold to store.

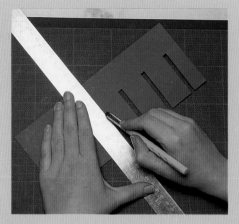

Cut evenly spaced slits from heavy stock.

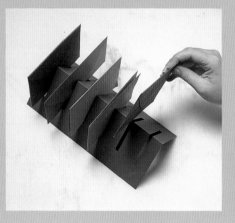

The rack allows your writing to dry without any items touching.

99 **WATERPROOFING** If you must waterproof your work (i.e. envelopes), be aware that most fixative sprays are highly toxic! To avoid inhaling harmful fumes, wear a protective dust mask and spray outdoors – which is better than spraying indoors, even in well-ventilated areas. To avoid spraying, experiment with waterproof inks and markers, thinned acrylic paints, or try rubbing lightly with a candle.

100

ALPHABET PIECES Calligraphers enjoy executing pieces using the alphabet as the text. Try this as a spontaneous exercise, and/or as a planned design. Explore the possibilities of stacking or overlapping letters, intertwining them, sharing common strokes, superimposing layers, adding decorative elements, etc. Alphabet pieces afford a wonderful opportunity to investigate the tools and techniques in this book, while creating an exciting interplay of letters!

Judy Kastin, *Alphabet.*
A pointed brush was used for the lettering. The background was applied with a sponge on watercolor paper.

FOR INFORMATION ON CALLIGRAPHIC GUILDS, SUPPLIES AND PUBLICATIONS

Society of Scribes, Ltd.
P O Box 933
New York, NY 10150,
USA

Friends of Calligraphy
Box 425194
San Francisco, CA 94142,
USA

Society of Scribes &
Illuminators
6 Queen Square
London
WC1N 3AR
U.K.

CLAS
c/o Sue Cavendish
4 Boileau Road
London
SW13 9BL

Letter Arts Review
1624 24th Avenue SW
Norman, OK 73072
(405) 364-8794
Toll-free in the USA
800 348-PENS
e-mail
letterarts@netplus-netu
(Website address:
letterarts.com)

CREDITS

Art editor Elizabeth Healey
Designer Tanya Devonshire-Jones
Photographer Laura Wickenden
Text editor Karyn Gilman
Senior editor Kate Kirby
Picture researcher Susannah Jayes
Picture manager Giulia Hetherington
Editorial director Mark Dartford
Art director Moira Clinch

Typeset by Genesis Typesetting, Rochester
Manufactured in Singapore by
Bright Arts (Singapore) Pte Ltd
Printed in China by Leefung-Asco Printers Ltd

Illustrations and artwork by Judy Kastin
#16, 34, 37, 43, 55, 58, 60, 61, 62(–3), 66, 86, 88, 100
**All other illustrations and artwork are by Annie Moring
unless noted otherwise.**
All demonstrations are by Annie Moring.

Tip 20 – Mary White – *The Sun*
From 'The Waves' by Virginia Woolf – Hogarth Press
(1931), Courtesy of the Estate of Virginia Woolf and
Hogarth Press © Quentin Bell & Angelica Garnett
(1931)

Tip 40 – Nancy Leavitt – *The Seafarer*
Anonymous author 10th century Exeter book, published
by Walter Tisdale, Tatlin Books, Bangor, ME; translation
by Karl Young, Kenosha, Wisconsin.

Tip 51 – *Stopping by Woods on a Snowy Evening*
Poem by Robert Frost

ACKNOWLEDGEMENTS
With grateful appreciation to my fellow calligraphers
who have so generously shared their tips and techniques
over the years. Special thanks to Kate Kirby for her
enthusiasm and patience, Karyn Gilman for her excellent
suggestions, Marcy Robinson for her helpful comments,
Annie Moring and all the scribes who shared their
incredible talents, and Elizabeth Healey and everyone at
Quarto Publishing for making this book a reality.